For Jim,

Christmas, 1993

May these pages bring you
wonderful memories of sights
seen and glimpses of adventures
yet to come.

You are a very treasured
friend! With love,
Lynn,

D0572561

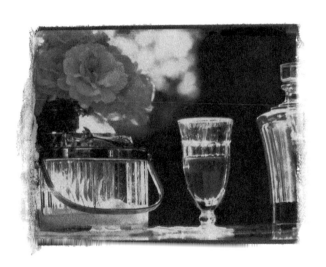

FRENCH

Photographs by Steven Rothfeld

INTRODUCTION BY RICHARD REEVES

DREAMS

WORKMAN PUBLISHING, NEW YORK

Steven Rothfeld
French Dreams / photographs by Steven Rothfeld.
p. cm.
ISBN 1-56305-469-8: $19.95
1. France—Pictorial works. 2. Photography, Artistic. I. Title.
DC20.R67 1993
944—dc20 92-50934
 CIP

Workman books are available at special discounts
when purchased in bulk for premiums and sales promotions
as well as for fund-raising or educational use. Special
editions can also be created to specification. For details,
contact the Special Sales Director at the address below.

Workman Publishing Company, Inc.
708 Broadway
New York, NY 10003

Manufactured in Italy

First printing September 1993

10 9 8 7 6 5 4 3 2 1

For my mother
who encouraged the first adventure
and my father
who, as a soldier in France,
filled his canteen with champagne

ACKNOWLEDGMENTS

Although these photographs were made by one person, many people had a hand in the creation of this book. Among them are Peter Workman, who on extremely short notice received me and my work so graciously that Friday afternoon; Ruth Sullivan, the insightful and tasteful editor whose devotion to this project has in many ways equaled my own; Nancy Murray, the production artist extraordinaire; Lia Camara, the sensitive and patient graphic designer; and Kathy Ryan, the quintessential editorial assistant and ambassador of quotation permissions. I am indebted to the people at *European Travel & Life*, *Bon Appétit*, and *Travel & Leisure* for sending me on so many memorable journeys, and to my friends, colleagues, and travel companions scattered around the world: Jeanne Dzienciol, Walter and Patricia Wells, David Breul, Judy Fayard, Alec Lobrano, Karen Kaplan, Jean Rafferty, Janet Carlson-Freed, and Deborah Seaman.

Thank you, Susan Swan, for sharing the vision, and sweet Marika, for inspiring it.

INTRODUCTION

The Perfection of France

I *l était une fois....* Once upon a time when men used horses and carts to get around, wine could not travel more than a few miles. But there has never been a recorded time when the French and the Gauls before them did not consider wine one of the three or four essentials of life. So, at one time or another just about every square meter of France has been planted in vines. For each plot there are, in archives or memory, records of the size of the pebbles and their temperature in the sun which determines the sweetness of the grape.

"So we know which land is the best and which wine will be the best," said Jean Delmas, who makes wine, as his father did before him, from the grapes grown on a small rise surrounded by the houses and shops of a rather grey suburb near the city of Bordeaux. The place is called *"haut brion"*—"high hill" in old French—and the wine Delmas makes is called *Chateau Haut Brion.*

The wine is a gift of generations, a product of French precision. France, like God, is in the details. When a Frenchman criticizes a foreigner's French, he considers that a gift, too. The language is perfect, after all, and no one would knowingly defile it.

It took a long time for the French to create all this perfection. They are not people who believe you can't improve on nature. They have been doing it for centuries and they still do it every day. The flowers and trees in the *Jardin de Luxembourg* are brought in from greenhouses and warehouses outside Paris, changing with the season, the day or even the hour, if the weather changes. There

is a plan, a certain way to do things, and once you get it right, exactly right, it must be maintained and preserved. A description of the gardens by an American sitting there in 1826 could still serve: "Long, shady gravel walks over which the tall old trees, which are all regularly planted, form perfect arches—and directly in the center, a valley or lower level of ground in which there are little plats of flowers..." wrote Henry Wadsworth Longfellow to his brother. "You descend from the higher grounds to this little vale, which is an amphitheater, open towards the palace—by flights of stone steps...Here the people gather every evening at about six o'clock and laugh and talk 'till the gates are closed—at ten. The ladies sit to be looked at—and the gentlemen to look at them."

They still gather, adjusting each chair just so to catch that bit of sunlight or the eye of that girl reading over there. The angles are the work of the ages.

Just outside the gardens, at the corner of the rue de Vaugirard and the rue Corneille, there is a café called Au Petit Suisse. It is busy in the morning when people come in on the way to work for a *grand crème* or cigarettes. Then the dozen or so tables are empty most of the day. Except, that is, for a magic twenty minutes or so on winter afternoons.

Parisians ache for a bit of sun during the short afternoons from November to April. They begin to gather at the Suisse at two o'clock or three depending on the month. The sun, if there is any at all, will be moving then, pale and low, across the southern sky, shining across the Luxembourg into the café.

It can be the warmest place in Paris during those few minutes. The old windows, a little dusty, magnify the thin sunlight into visual perfume. Students sit alone with a book and a coffee, or together laughing and flirting, learning lessons about each other. Older men sit with *Le Monde* or perhaps just with memories and envy. Women come in from marketing, lavishly brushing cheeks with friends and gossiping for a bit. Then, too soon, the sun and everyone is on his way again. Someplace to go. Other rooms, other perfect corners of the hexagon.

The French call their country *Le Hexagone* because of its shape. They see their land as geometri-

cally perfect: Balanced. Rational. An elaborately worked piece of jewelry. This is a polished country. In fact, when I once used the phrase "cutting edge" in talking about the United States, a Parisian I know snapped and said, "The cutting edge! That's all Americans think about, cutting. Don't you ever think about polishing?"

Even the great symbol of modern France is an example of polished old technology, the TGV, *le Train de Grande Vitesse*, the physical link now between Paris and the valleys and villages of *la France profonde*. Deep France, the roots of the national character. Like Asians, the French remember where they came from—the wealth of the country came from agriculture, from the land—and they make holiday pilgrimages to their places in deep France.

It is a mistake, though, to romanticize the French determination to stay put and gild the merely beautiful. France is romantic, the French are not. "Stubborn" or "inspired" would be better words. "Even empty space is aligned according to a dominant idea: vistas, perspectives, and panoramas of monuments are all demonstrations of matters bent to mind," wrote Joan Juliet Buck, an American novelist who grew up in France, "confirmed by the absence of interfering buildings, as if the air itself had been trimmed to best express the will."

Some of those places—*un plaisir pour vos yeux*—are architectural or economic shells now or they are the summer homes of the absentee rich of Paris and the world. "You cannot tell that we are in the 20th century," I said to a French friend as we walked through a village near Gordes. "*Alors...*" she responded. "So, you're another American who wants us to live without television and cars and to freeze in the winter because it all looks so charming when you ride by."

I'm sorry. I forgot that what the French do, they do for themselves. There is always a perfectly logical reason. The rosebush at the end of each row of vines at *Haut Brion* is there as an early warning system; the roses are affected by certain plant diseases before the vines. The perfectly arched plane trees over the old roads in the south were planted by Napoleon because his troops could march farther and faster in their shade. Restaurants as we know them—as opposed to inns where

proprietors ladled out whatever was on the stove that night—came into being because the chefs of the nobility were unemployed after the French Revolution. And the sauces of France were a way to disguise the taste of meat which did not travel much better than wine. And, having chosen to honor the old and beautify the beautiful, the French live in smaller spaces than Americans—and their tighter family structures limit the privacy of young people in family space—so public places, parks or cafés, and the countryside, too, are the real living rooms and gathering places of the French. They understand public space and vistas and love them as Americans might love only their own homes.

That said, more often than not, it is the idea of perfection itself that is the reason the French do what they do. Here I should say that there is a small but telling loss in translation. Webster's first definition of the English word "perfect" is "complete in all respects"—that is, "sound," ready to go or to use. One might even whisper, "good enough." The first French definitions of *parfait* are "faultless, flawless." In other words, more care goes into the arranging and wrapping of a 40-franc bouquet on the Boulevard Raspail in Paris than the Baron Haussman took in laying out the boulevard itself. The shop windows and doorways have been planned to delight and, ideally, surprise—for hundreds of years. Serendipity is a controlled environment in France. Each display of cheese or chocolate or oysters: Faultless. Each table, each dish: Flawless. Each dress, the fall of each scarf, each signature: Perfect. More: Parfait!

They are not an easy people, the French. More than once I have seen a reverse Alphonse-et-Gaston act played out on the streets. Two drivers making turns blocked each other and then refused to back off to let the other go first. In each case I saw, both drivers rolled up their windows, locked the doors, and folded their arms across their chests. Once, I watched for fifteen minutes and no one moved—and no one but me payed any attention.

That is, I suppose, the kind of focused determination it takes to preserve a special beauty. "Living with the French is like having a sharp little stone in your shoe," said a friend, who was the Canadian consul in Paris. "It's annoying, but, by God, they remind you you're alive!"

The most basic difference between them and us, Americans, is that when asked whether something is possible, we always say "yes" and they always say *"non."* They mean that whatever it is under negotiation is not perfect or cannot be done perfectly. Alexis de Tocqueville was shocked when he came to the New World in 1830 and saw the shoddy construction of American ships, insults when compared with the craftsmanship of the French. He told a shipbuilder that he thought the ships there could not last more than ten or fifteen years. Yes, the American said, but by then there will be new technologies and new ships.

The French care. Under cover of all that Cartesian logic, they are aware of the modernist contradictions and tensions in their lives. The perfection of France is not an act of God, it is an act of will. In the valley of the Dordogne in south-central France, my wife and I came upon a woman selling old linens, mostly heavy cotton country nightgowns, out of her barn. My wife bargained some on the price, until the woman said, "I'm sorry, I just can't sell them for less. The buyer from Laura Ashley comes tomorrow, and she'll pay whatever I ask."

Looking from her place, across the valley and the river up to the mountains and the perched town of Domme, you could not tell which century you were in. That is a cliché, of course, but clichés survive because they express something universal. The perfection of France is expressed in such views and, conversely, in the places from which they are seen.

And, because of that, France, which can seem the coldest of countries and the crankiest of nations, is the most welcoming and familiar of places. Beauty and art exist to be shared, so no one can come as a total stranger. The works of man are done to be seen and used by other men. In this world and this time, the great surprises are the places of the heart and the eye that do not change.

Richard Reeves

FRENCH

DREAMS

"Tout arrive en France."

La Rochefoucauld

Perhaps it was flowers that made me a painter.

Claude Monet

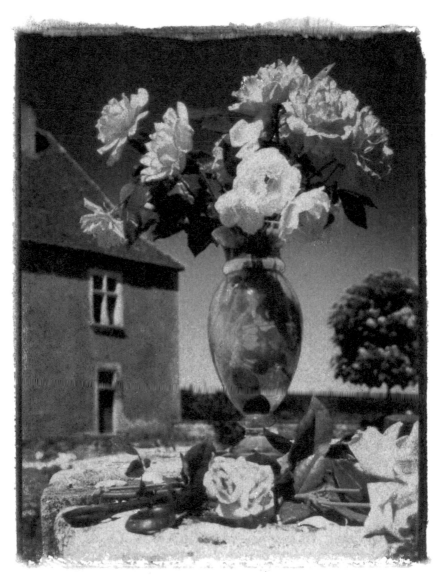

Roses Regagnac

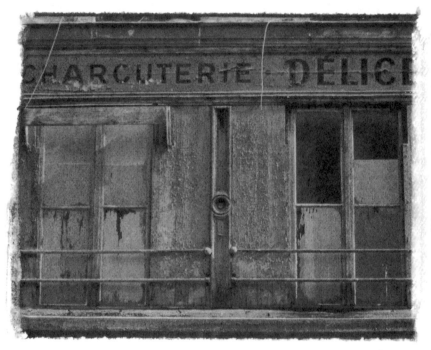

Façade Paris

aris in indeed an ocean. Sound it: you will never touch bottom.
Survey it, report on it! However scrupulous your surveys and reports, however

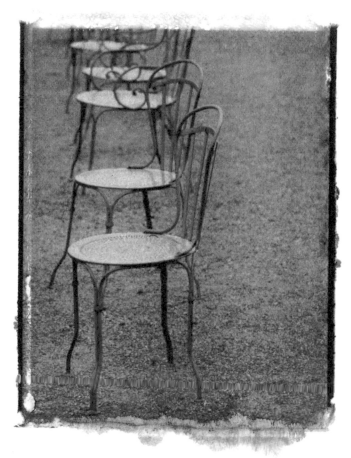

Luxembourg Paris

numerous and persistent the explorers of the sea may be, there will always remain virgin places, undiscovered caverns, flowers, pearls, monsters...

Honoré de Balzac

*I*n France everything speaks of long familiar intercourse between the earth and its inhabitants; every field has a name, a history, a distinct place of its own in the village polity; every blade of grass is there by an old feudal right which has long since dispossessed the worthless aboriginal weed.

Edith Wharton

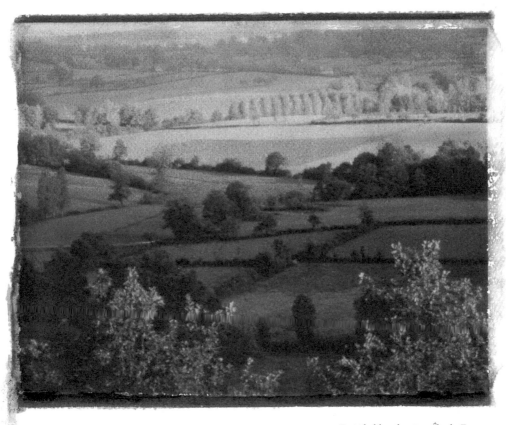

Dappled landscape Île-de-France

The almond trees were in

flower and the peaches in

bud. The spring wildflowers on

the terraces changed from one

day to the next: anemones, lilies,

cyclamens. The air was heavy

with the smell of flowers, and as

I climbed the fragrance grew still

more intense.

W.S. Merwin

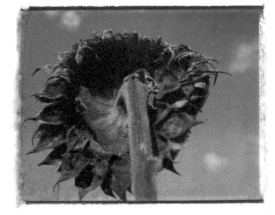

Sunflower l'Îsle-sur-la-Sorgue

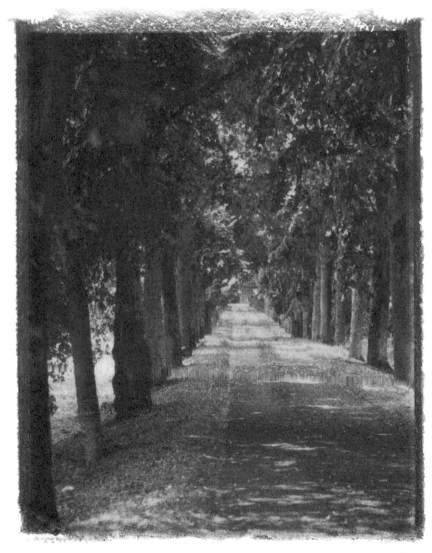

Allée St. Rémy

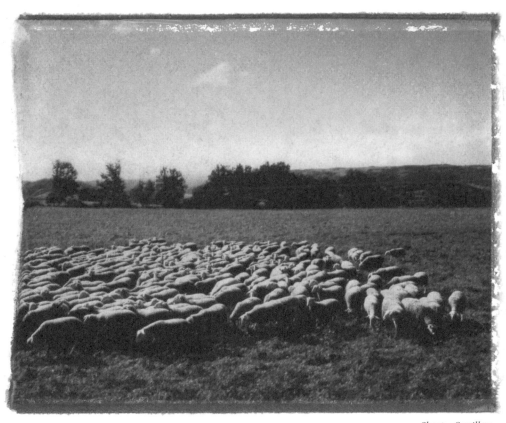

Sheep Souillac

The wandering life is what I like. To journey on foot, unhurried, in fine weather and in fine country, and to have something pleasant to look forward to at my goal, that is of all ways of life the one that suits me best.

Jean-Jacques Rousseau

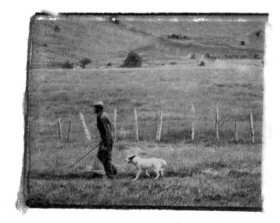

Paysan Auvergne

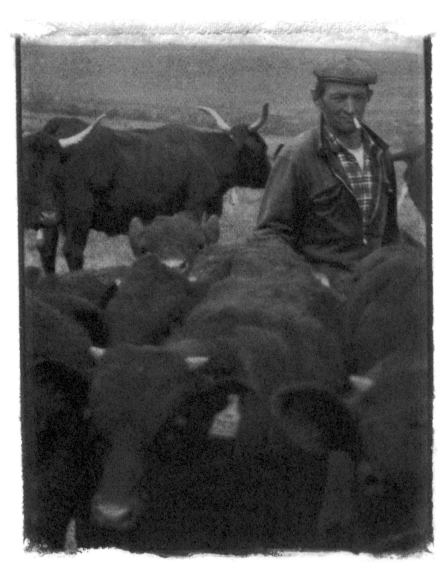

Cowboy Auvergne

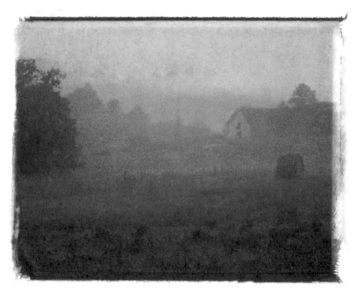

Dawn Le Buisson

I would like to be Pierrouni the little cow-herd, and to go, a branch in my hand...to lead the cows to graze in the pasture, near the blackberries, not far from the orchard.

Jules Vallès

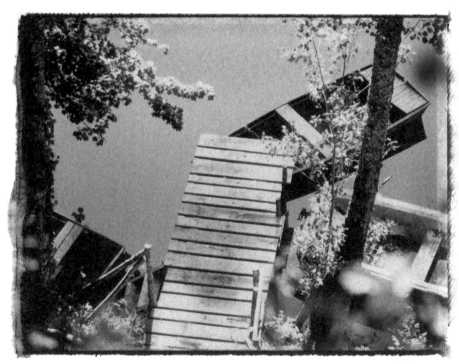

Dock Sourzac

*T*he graceful rowing-boat has been pulled up onto the grass; the cushions have been taken from it so that the ladies, who were afraid of dampness for their new dresses, could sit down; then the food was taken out...the inevitable pâté was cut open and the bottles uncorked.

L'Illustration, 15 June 1878

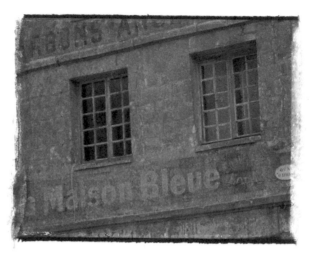

Pentimento Honfleur

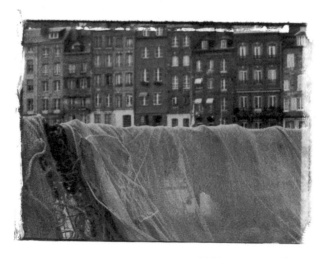

Fishing nets Honfleur

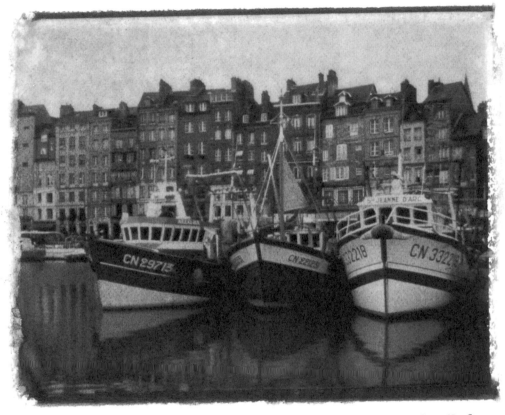

Port Honfleur

A port is a delightful place of rest for a soul weary of life's battles.

Charles Baudelaire

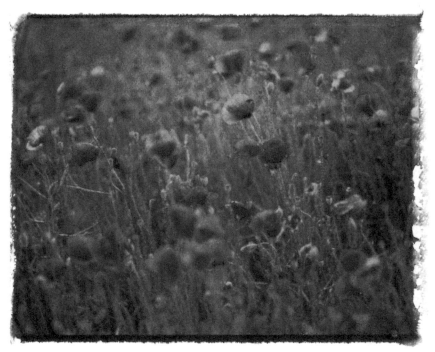

Poppies Arpaillargues

Leaves and flowers crowd together and understand each other....

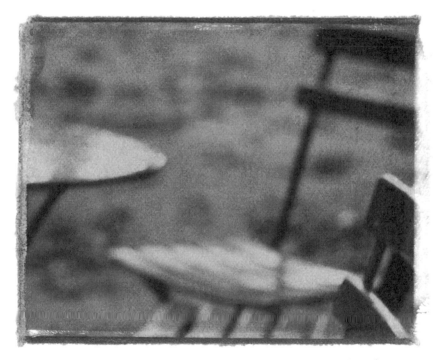

Après-midi Paris

Other people will come to sit on the iron chair.

Other people will watch it when I am no longer here.

The night will forget the ones who loved it so much.

Léon-Paul Fargue

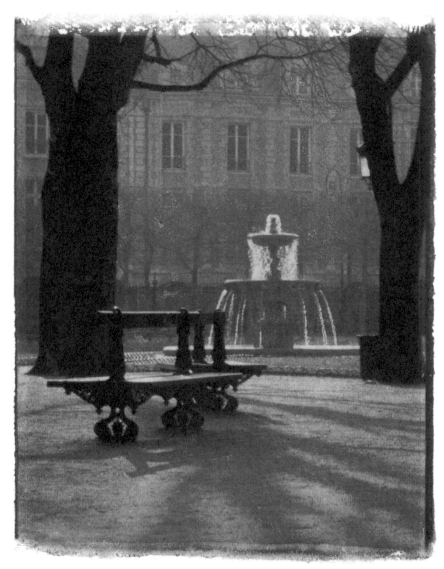

Place des Vosges Paris

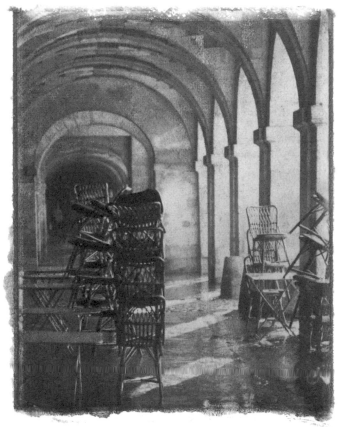

Arcade Paris

*V*elvety shadows had fallen over the Place des Vosges, where the tinkle of the fountains rang out more loudly, one of the four, always the same one, having a shriller note than the others.

Georges Simenon

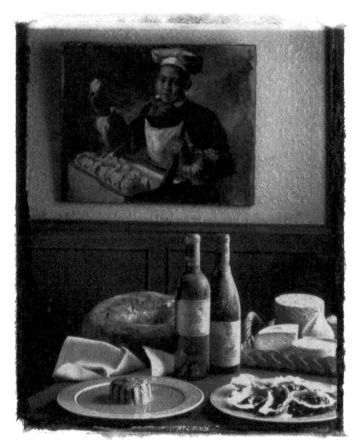

Still life Lyon

The Parisian travels but little, he knows no language but his own, reads no literature but his own, and consequently he is pretty narrow, and pretty self-sufficient. However,

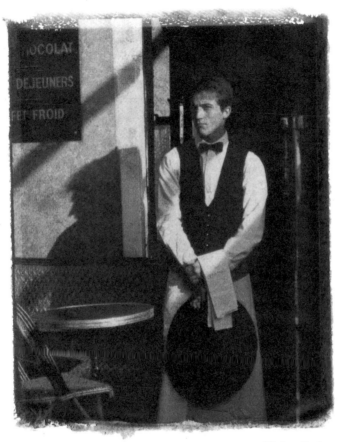

Waiter Paris

let us not be too sweeping; there are Frenchmen who know languages not their own: these are the waiters.

Mark Twain

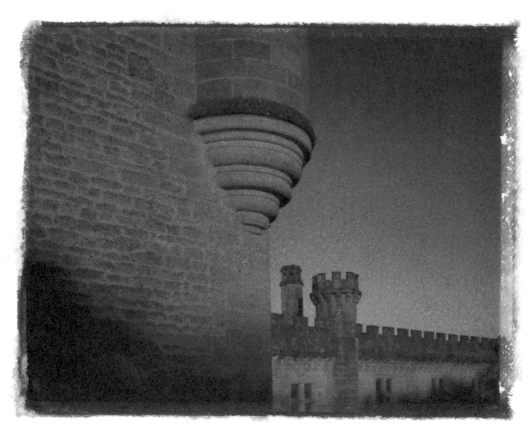

Crenellation Sarlat

*S*uddenly he saw, at the end of a long avenue of trees, a strong light. It seemed to be some distance away, but he walked towards it, and presently discovered that it came from a large palace, which was all lit up.... "This palace," he said to himself, "must surely belong to some good fairy, who has taken pity on my plight."

Beauty and the Beast

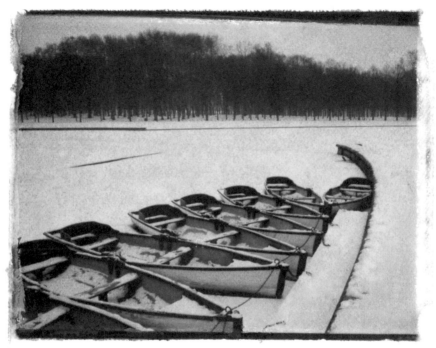

Winter Versailles

Winter, season of art serene, lucid winter...

Stephane Mallarmé

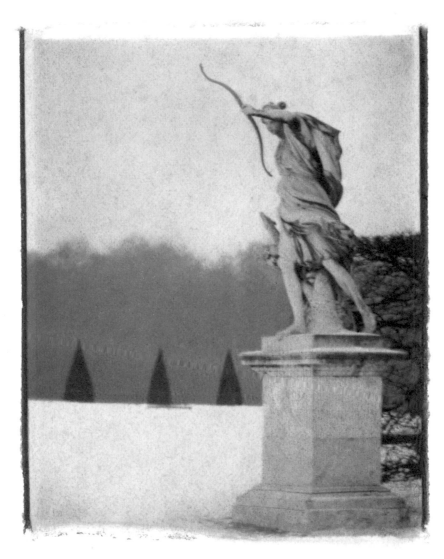

Statue Versailles

t may be the merest one-room pied-à-terre: as long as I have that I feel a complete man…the highest thoughts in the world have been thought in those grey buildings and streets….It is that here every stone calls up the memory of a great artist.

Ford Madox Ford

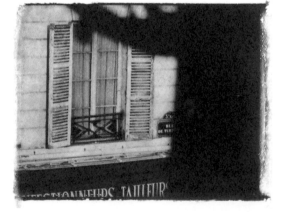

Pied-à-terre Paris

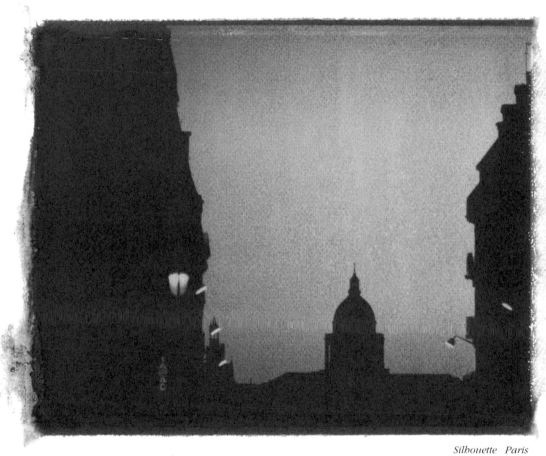

Silhouette Paris

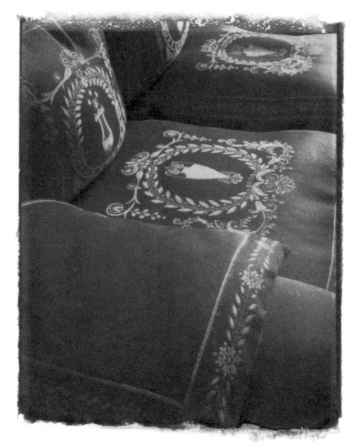

Imperial sofa Paris

When I dream of afterlife in heaven, the action always takes place at the Paris Ritz.

Ernest Hemingway

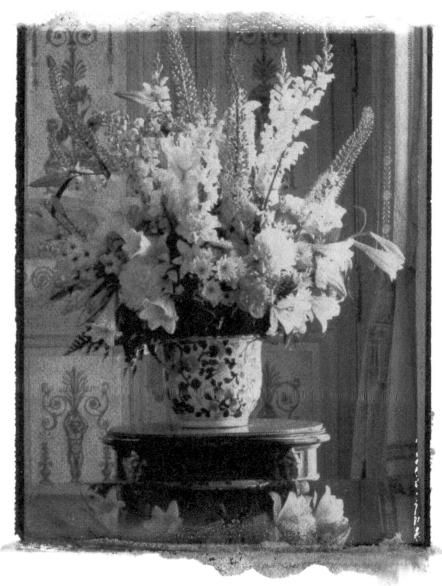

Ritz Paris

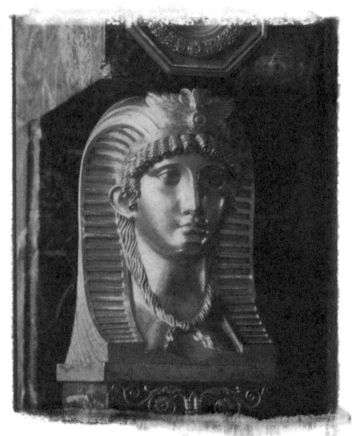

Retour d'Egypt Paris

W as it fun in Paris?...was the Madeleine pink at five o'clock and did the fountains fall with hollow delicacy into the framing of space in the Place de la Concorde, and

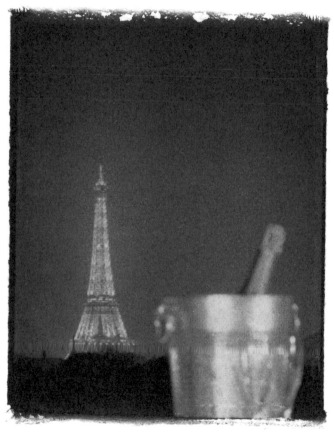

Fête Paris

did the blue creep out from behind the Colonades in the rue de Rivoli...and were there lights at night and the click of saucers and the auto horns that play de Bussey?

Zelda Fitzgerald

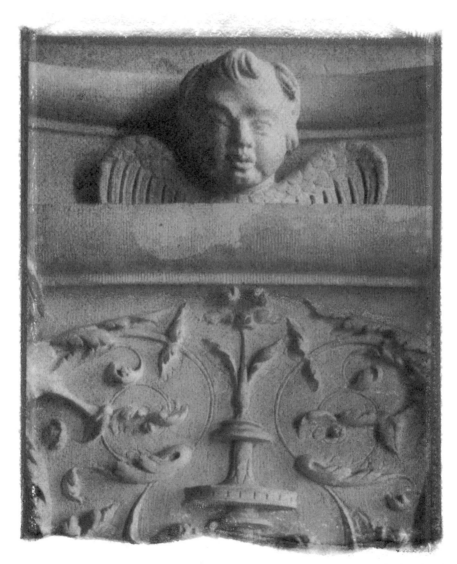

Bas-relief Chambord

Fear then, in the blind wall the prying glance:
A voice is attached to matter itself...

"Everything is sentient!"
And everything has power upon you.

<div align="right">

Gérard de Nerval

</div>

Balustrade Chambord

*T*he furniture appears to be dreaming; it seems endowed with a

somnambulistic life, like vegetables or minerals. The cloth materials

speak a silent language, like flowers, like skies, like setting suns.

Charles Baudelaire

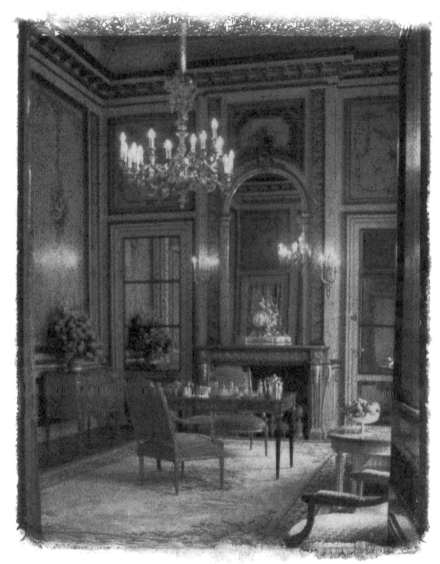

Salon Paris

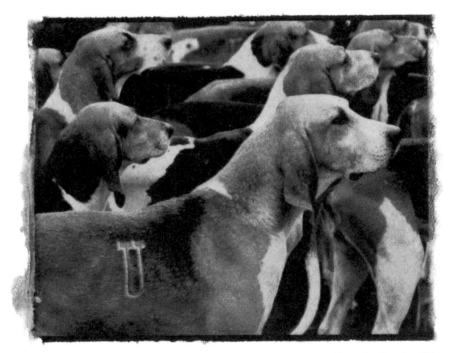

Hounds Rambouillet

Chasse à Courre Rambouillet

Memories are hunting horns
Whose sounds die along the wind.

Guillaume Apollinaire

*I*n the end you are weary of this world so old

 Shepherdess O Eiffel Tower the flock of bridges is bleating this morning

You've had enough of living amid Greek and Roman monuments

 Apollinaire

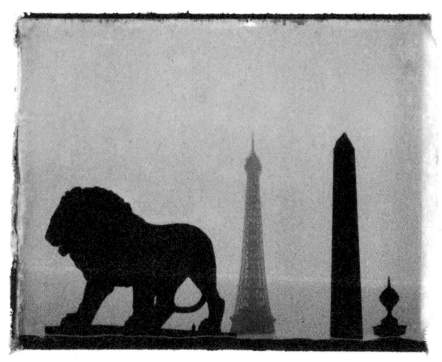

Eiffel Tower Paris

Cathedral Chartres

Gothic Chartres

I spent a long time looking at this monument. I revolved around it, like a moth around a candle; I went away and I came back; I chose twenty differ-ent standpoints; I observed it during the different hours of the day, and saw it in the moonlight as well as the sunshine. I gained, in a word, a certain sense of familiarity with it; and yet I despair of giving any coherent account of it.

Henry James

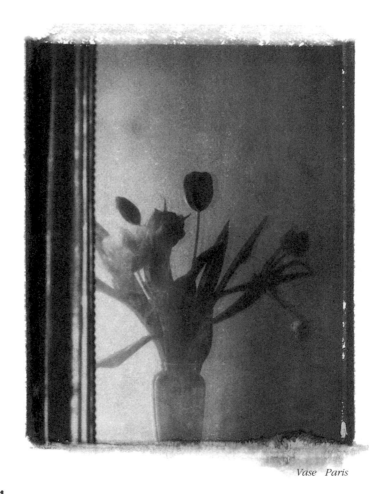

Vase Paris

𝒲hat one can see out in the sunlight is always less interesting than what goes on

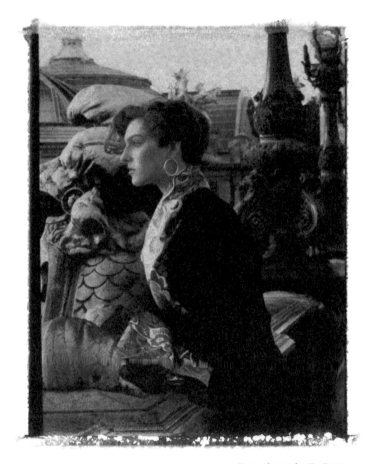

Pont Alexandre II Paris

behind a window pane. In that black or luminous square life lives, life dreams, life suffers.

Charles Baudelaire

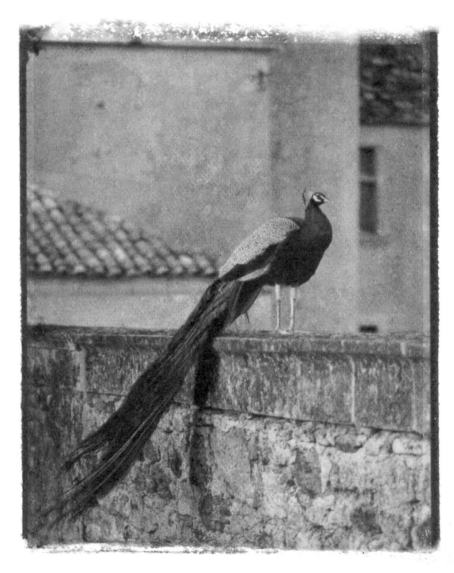

Peacock Beaumont

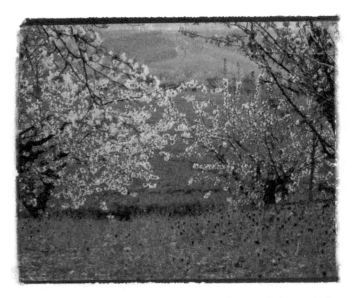

Spring Chalon-sur-Saône

*t*hen, as I drew near, the sight of their topmost branches, their lightly tossing foliage, in its easy grace, its coquettish outline, its delicate fabric, over which hundreds of flowers were laid, like winged and throbbing colonies of precious insects...

Marcel Proust

Under the blue sky the orange, yellow, red splashes of the flowers take on an amazing brilliance, and in the limpid air there is a something or other happier, more lovely than in the North…

Vincent van Gogh

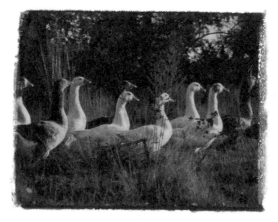

Geese Saint-Jean-d'Ardières

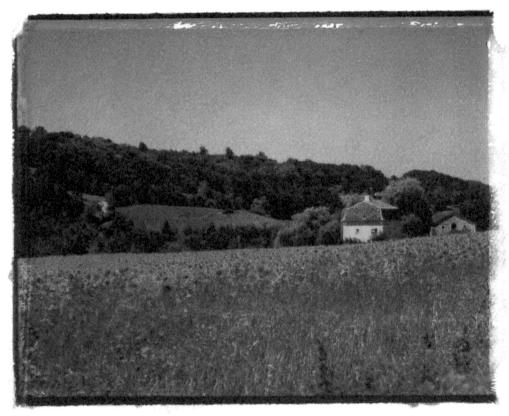

Summer Lalinde

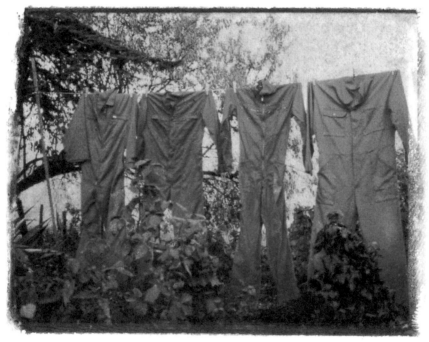

Salopettes Morgon

T he precious things in France are usually little things. What is adorable is what

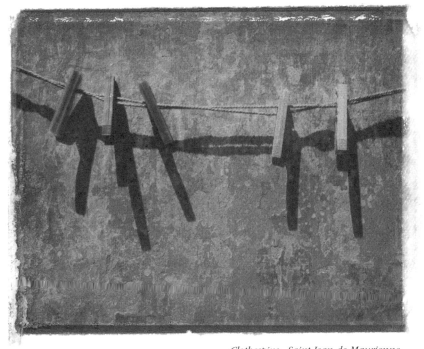

Clothespins Saint-Jean-de-Maurienne

is mignon....You do not have to crook your neck to see the wonders of France.

Henry Miller

*A*n immense stretch of flat country, a bird's-eye view of it seen from the top of a hill—vineyards and fields of newly reaped wheat. All this multiplied in endless repetitions.

Vincent van Gogh

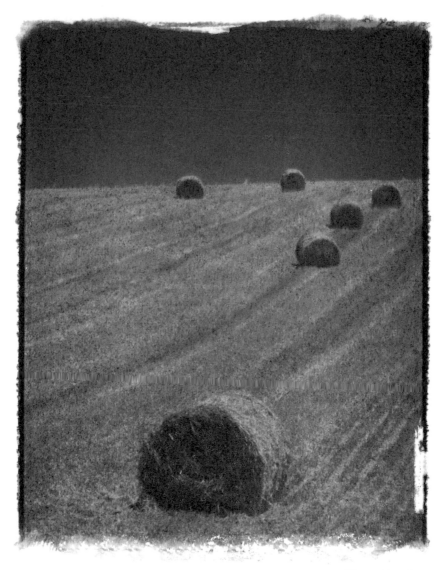

Wheat Mussidan

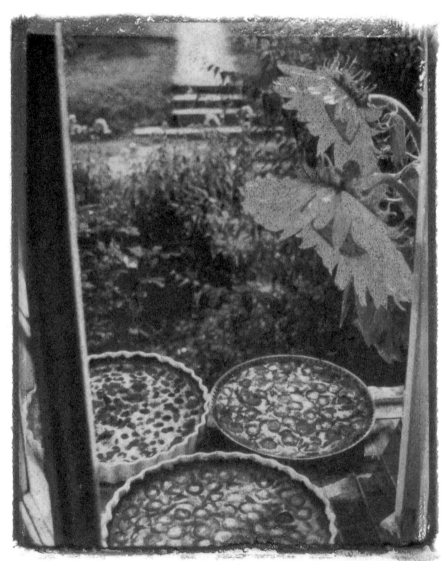

Clafoutis Saint-Astier

*T*his is the landscape in which to read slowly, lingeringly, those flowing periods in *La Physiologie du Goût* which have transformed the mere act of eating into a philosophy.... Brillat-Savarin came from fabulous, immortal stock.... one of his sisters, two months before her hundredth birthday, uttered her last words—words which are graven in the heart of every true gastronome. They were 'Vite, apportez moi le dessert, je sens que je vais passer'. (Quick, bring in the dessert, I feel I'm going.)

Lawrence Durrell

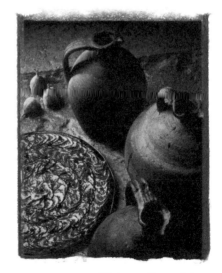

Tarte aux figues Joigny

I have kissed the summer dawn.

Before the palaces, nothing moved. The water lay dead.

Battalions of shadows still kept the forest road.

I walked, waking warm and vital breath,

While stones watched, and wings rose soundlessly.

My first adventure, in a path already gleaming

With a clear pale light,

Was a flower who told me its name.

Arthur Rimbaud

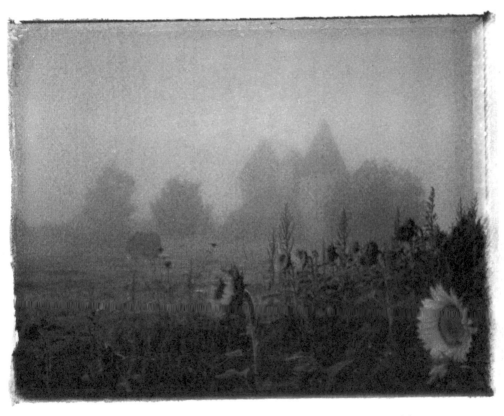

Château Le Buisson

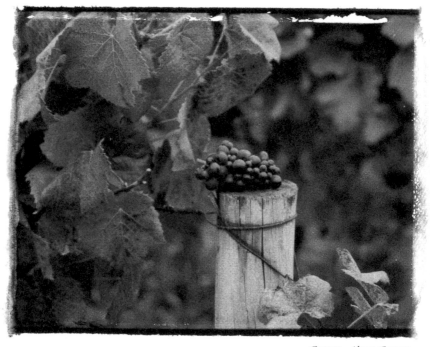

Grapes Aloxe-Corton

V oices hazy with early morning fatigue arose from the heights of a neighboring vineyard and then declined, descending ever lower as the sun rose higher. I could picture the slow

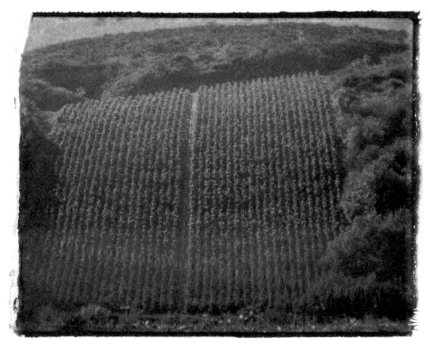

Cascade Avenas

work of picking, the baskets filled, the increasingly parched throats of any who thought to slake their thirst by biting into a bunch.

Colette

*A*nd then suddenly you see a valley,

Humid, silent and green, covered in lilacs, a stream,

Murmuring between poplars—and very soon

The roar of the road is quite forgotten.

Gérard de Nerval

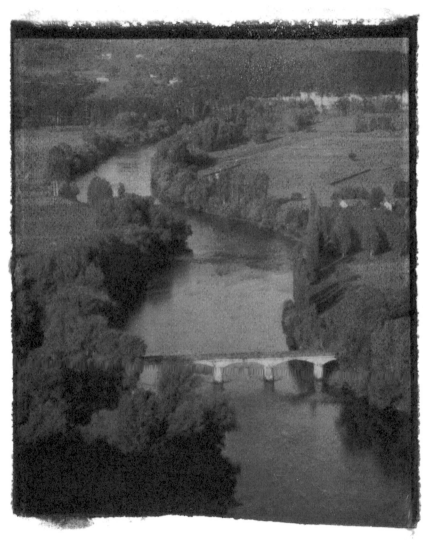

River Domme

View Eze-Village

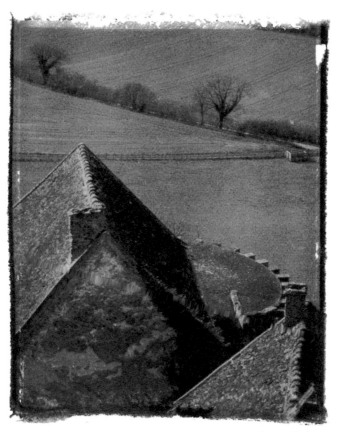

Rooftops Vézelay

*A*ll day the wind blows
and the rock
keeps its place

W. S. Merwin

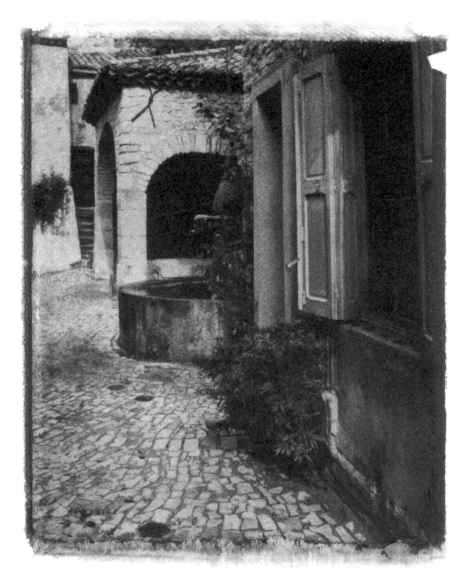

Fountain Vaison-la-Romaine

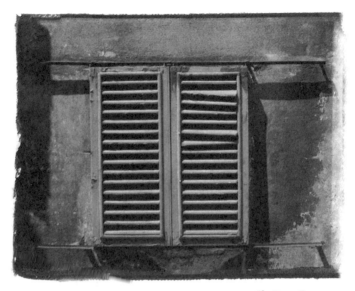

Shutters Provence

*S*uch visual awareness must take in the most minute details of domestic architecture—the colour and shape of shutters, the position and size of doors and windows, the tiny hints afforded by a staircase off a dark courtyard, as it curls upwards, the tempting threshold between what is public and visible and what is private, yet suggestible.

Richard Cobb

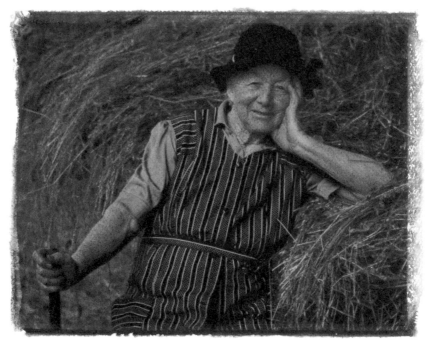

Woman and haystack Aurillac

*F*rench people really do not believe that anything is important
except daily living.... It is nice in France they adapt themselves

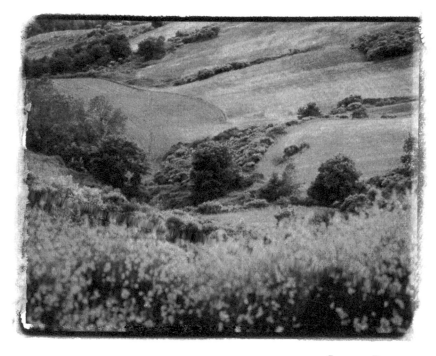

Paysage Provence

to everything slowly they change completely but all the time they know that they are as they were.

Gertrude Stein

*W*hat color do you think the trees have been for the last week? Answer me! You will say, "green." Not so! They are red! There are little buds, all ready to open up, which are truly red, but then they all unfurl and make a little leaf, and since they do not come out all at once, the effect is a lovely mixture of red and green. All this is hatched out under our very eyes.

Madame de Sévigné

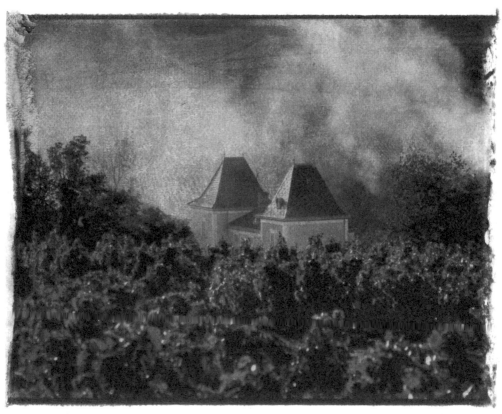

Brouillard Juliénas

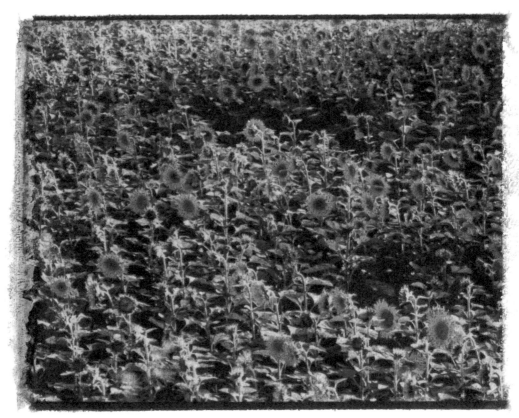

Field Dordogne

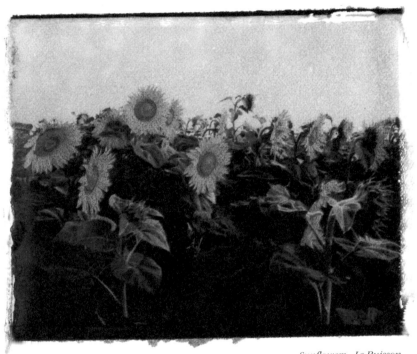

Sunflowers Le Buisson

All this beautiful Provençal landscape lives by light.

Alphonse Daudet

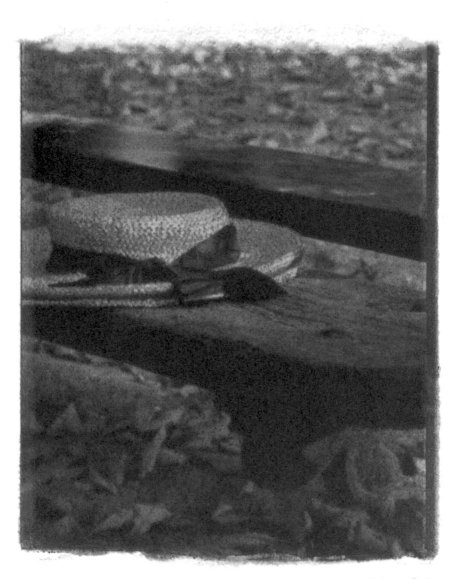

Autumn Paris

The shadow of twilight was falling; the sun between the branches dazzled the eyes. Here and there around her, in the leaves or on the ground, trembled luminous patches, as if humming-birds flying about had scattered their feathers. Silence was everywhere; something sweet seemed to come forth from the trees; she felt her heart, which began to throb again, and the warm blood coursed through her veins like a stream of milk. Far away, beyond the wood, on the other hills, she heard a vague prolonged cry, a voice which lingered, and in silence she heard it mingling like music with the last pulsations of her throbbing nerves.

Gustave Flaubert

Allée sauvage Sarlat

When they took something from the outside like...the Austrian croissant brought by Marie Antoinette, they took it over so completely that it became French so completely French that no other nation questions it.

Gertrude Stein

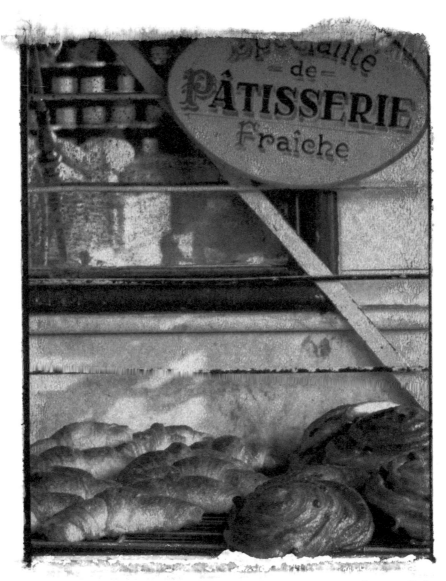

Boulangerie Paris

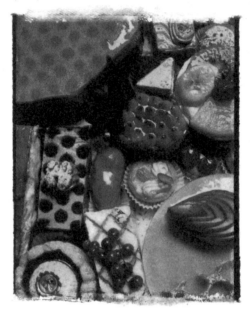

Mosaic Paris

*I*f I had compared my life to a cake, the sojourns in Paris would have represented the chocolate filling. The intervening layers were plain sponge. But my infatuations do not begin at first taste. I nibble, reflect, come back for more, and find myself forever addicted.

A.J. Liebling

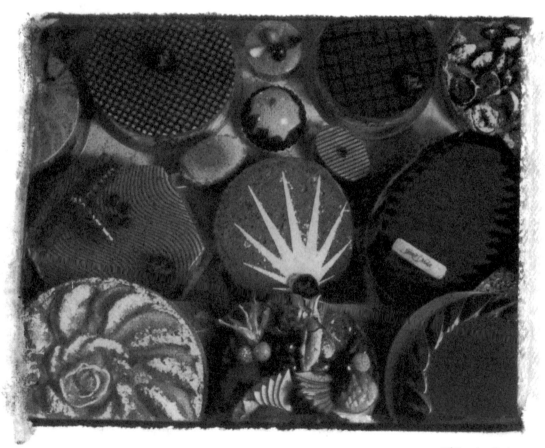

Pâtisserie Paris

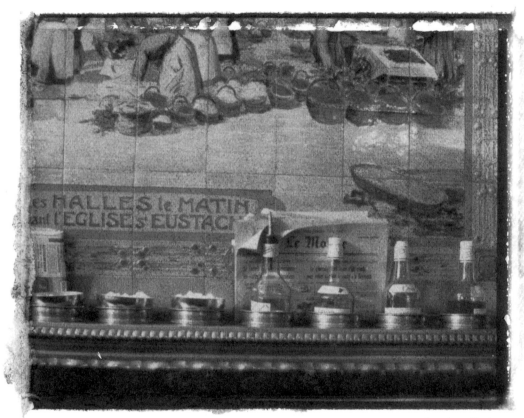

Zinc bar Paris

arisians devote a good part of their day to marketing, and it's obvious that what many Frenchmen do between meals is make shopping lists, market, and talk about meals past and meals future.

Patricia Wells

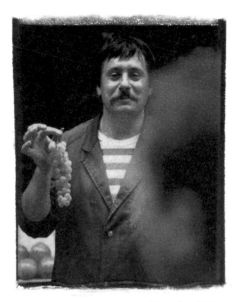

rue Poncellet Paris

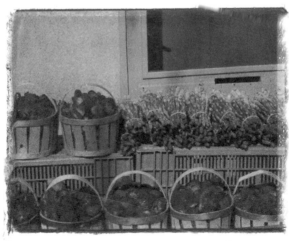

Tuesday Vaison-la-Romaine

We entered the farmhouse. The smoky kitchen was high and spacious. The copper utensils and earthenware glistened under the reflection of the big fire. A cat lay asleep under the table. Within, you inhaled the odor of milk, of apples, of smoke, that indescribable smell peculiar to old houses where peasants have lived—the odor of the soil, of the walls, of furniture, of stale soup, of washing…. and of things that have passed away.

Guy de Maupassant

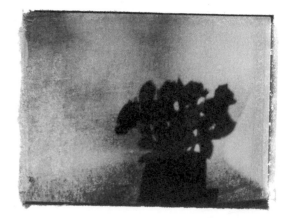

Gravestone Montparnasse

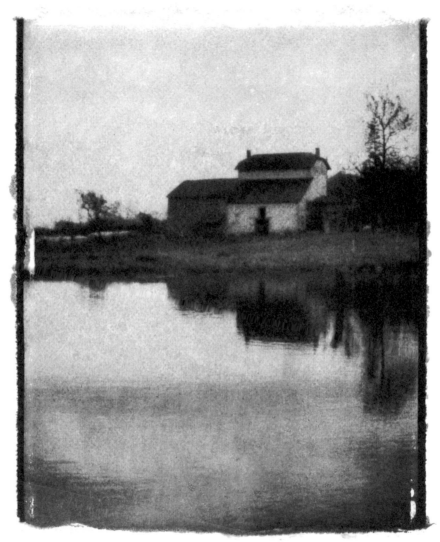

Farmhouse Chatêauponsac

Out of every wandering in which people and places come and go in long successions, there is always one place remembered above the rest because the external or internal conditions were such that they most nearly produced happiness....One cannot divine nor forecast the conditions that will make happiness; one only stumbles upon them by chance, in a lucky hour, at the world's end somewhere, and holds fast to the days, as to fortune or fame.

Willa Cather

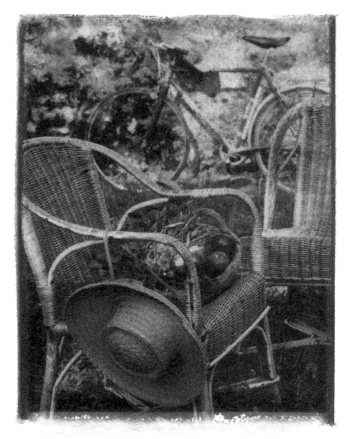

Chairs Regagnac

SOURCES

The passages in **French Dreams** *were excerpted from the following works:*

CREDITS

For permission to use copyrighted or protected material, we thank the following literary executors and publishers. We have made every effort to obtain permission to reprint material in this book and to publish proper acknowledgments. We regret any error or oversight.

Honoré de Balzac, *Pere Goriot.* Translation © 1962 by Henry Reed; bibliography © 1981 by New American Library, a division of Penguin Books USA, Inc. Reprinted by permission.

W. S. Merwin, *The Lost Upland.* © 1993 Alfred A. Knopf; reprinted by permission.

Jean-Jacques Rousseau, *The Confessions I*, Book 4. Translation © 1954 by J. M. Cohen, Penguin Classics. Reprinted by permission.

Charles Baudelaire, "The Port," from *20 Prose Poems.* © 1946, 1968, 1988 by Michael Hamburger, City Lights Books. Reprinted by permission.

Léon-Paul Fargue, "Nocturne." Excerpted from *The Random House Book of 20th Century French Poetry*, edited by Kenneth Rexroth. Reprinted by permission of the Kenneth Rexroth Trust.

Georges Simenon, "Madame Maigret's Admirer," from *Maigret's Pipe.* Translation © Jean Steward, Penguin Classics; reprinted by permission.

Ford Madox Ford, *It Was the Nightingale.* © 1923 by Ford Madox Ford, renewed 1961 by Catherine Lamb. Reprinted by permission of Janice Biala.

Gérard de Nerval, *Selected Writings.* Translation © 1957 by Geoffrey Wagner. Reprinted by permission of University of Michigan Press.

Charles Baudelaire, "The Double Room," from *20 Prose Poems.* © 1946, 1968, 1988 by Michael Hamburger, City Lights Books. Reprinted by permission.

Guillaume Apollinaire, *Alcools.* © 1920 Éditions Gallimard; reprinted by permission.

Charles Baudelaire, "Windows," from *Paris Spleen.* © 1970 New Directions Publishing Corporation; translated by Louise Varèse. Reprinted by permission.

Marcel Proust, *Swann's Way.* © Vintage Books/Random House; translated by C. K. Scott Moncrieff. Reprinted by permission.

Vincent van Gogh, *Letters from Provence.* © 1990 Little, Brown and Company; reprinted by permission.